We Like To Live

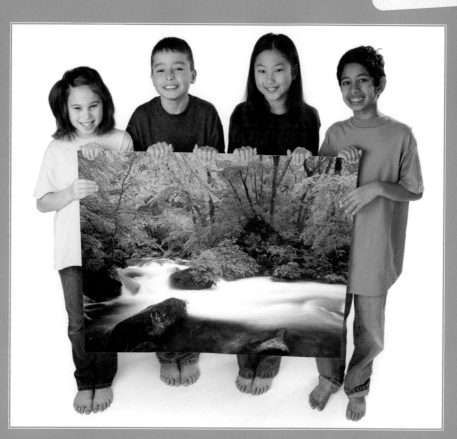

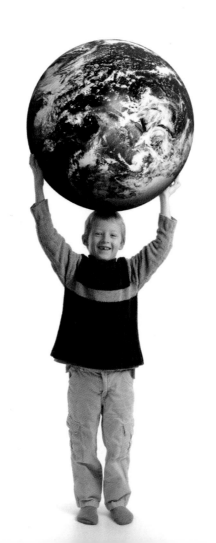

We Like to Live Green

MARY YOUNG

Design by
Zachary Parker

World Health Series

HOHM PRESS
Prescott, Arizona

For our Mother Earth and children everywhere.

Cover design, interior layout and design: Zac Parker, Kadak Graphics, Prescott, AZ.

Library of Congress Cataloging-in-Publication Data

Young, Mary
We like to live green / Mary Young ; design by Zachary Parker.
 p. cm. -- (World health series)
ISBN 978-1-935387-00-8 (pbk. : alk. paper)
1. Environmental protection--Citizen participation--Juvenile literature. 2. Sustainable living--Juvenile literature. I. Parker, Zachary, ill. II. Title.
TD171.7.Y685 2009
333.72--dc22
 2009019690

HOHM PRESS
P.O. Box 2501
Prescott, AZ 86302
800-381-2700
http://www.hohmpress.com

This book was printed in China.

PREFACE

Educators everywhere are concerned with helping to develop awareness of ecological concerns. This little Earth-friendly book provides a basic introduction to vital environmental themes offered in ways that are appealing to both young children and adults. Presented in colorful, lively photo montages, it introduces ways to make a difference in a world threatened by pollution and ecological imbalance and inspires the joy of loving and appreciating the Earth, our home.

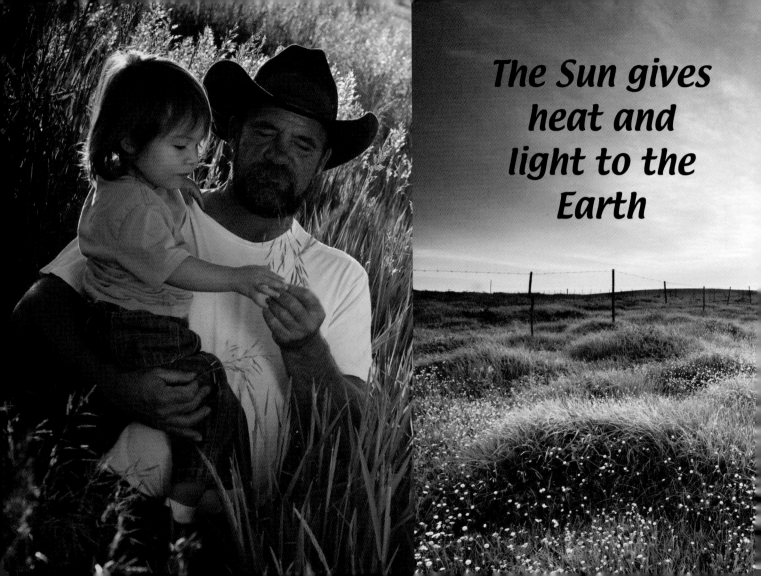

The Sun gives heat and light to the Earth

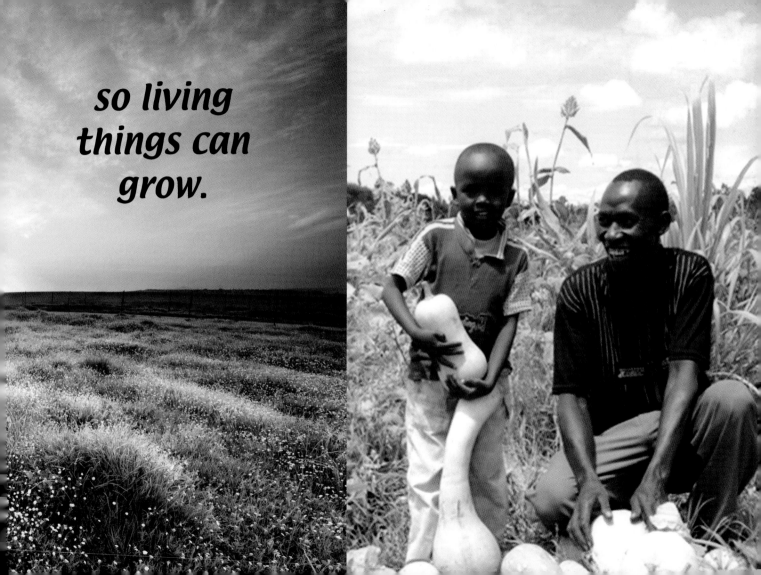

so living things can grow.

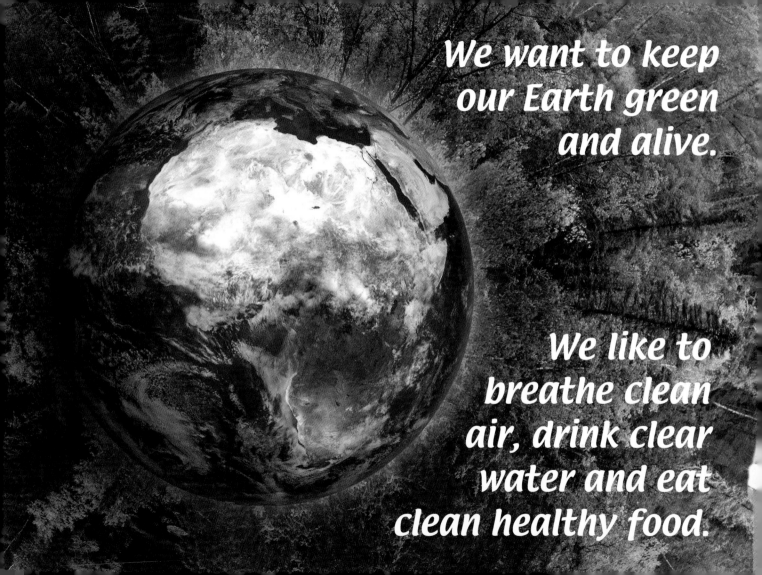

We want to keep
our Earth green
and alive.

We like to
breathe clean
air, drink clear
water and eat
clean healthy food.

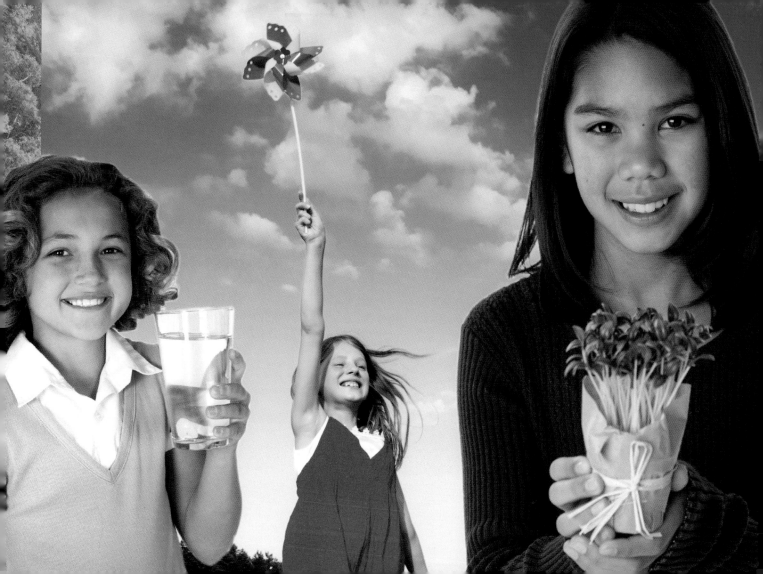

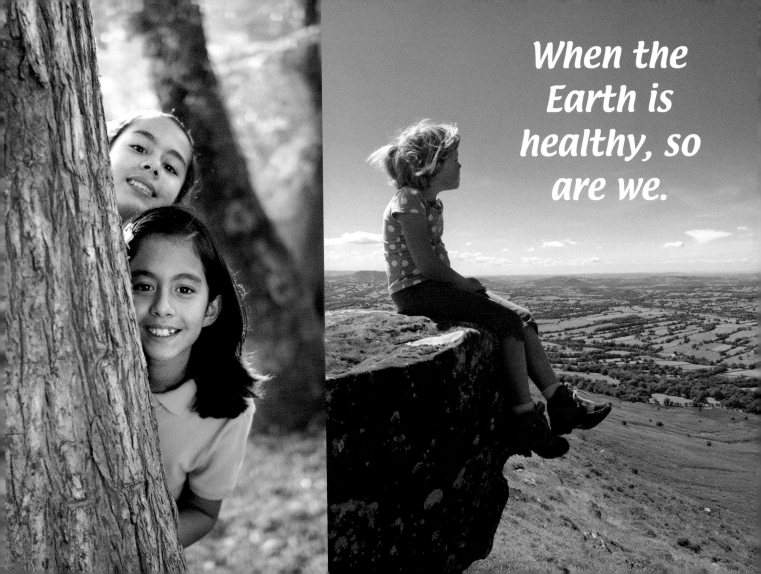

When the Earth is healthy, so are we.

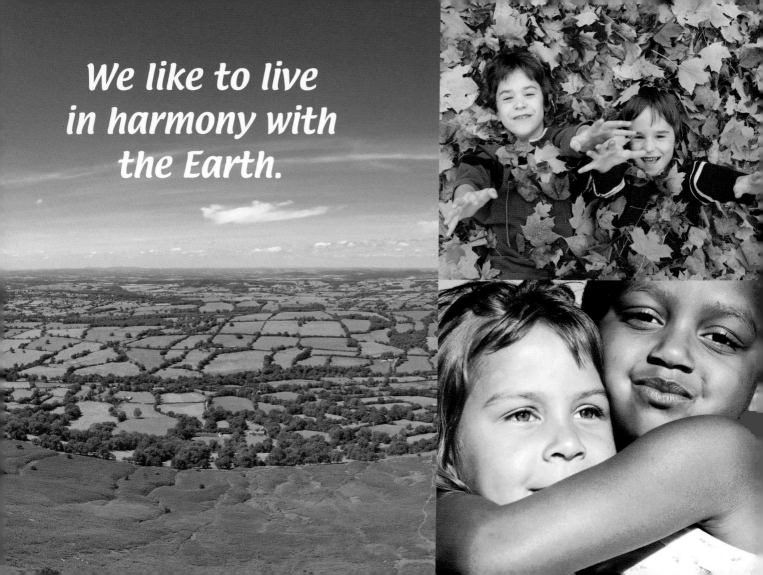

We like to live in harmony with the Earth.

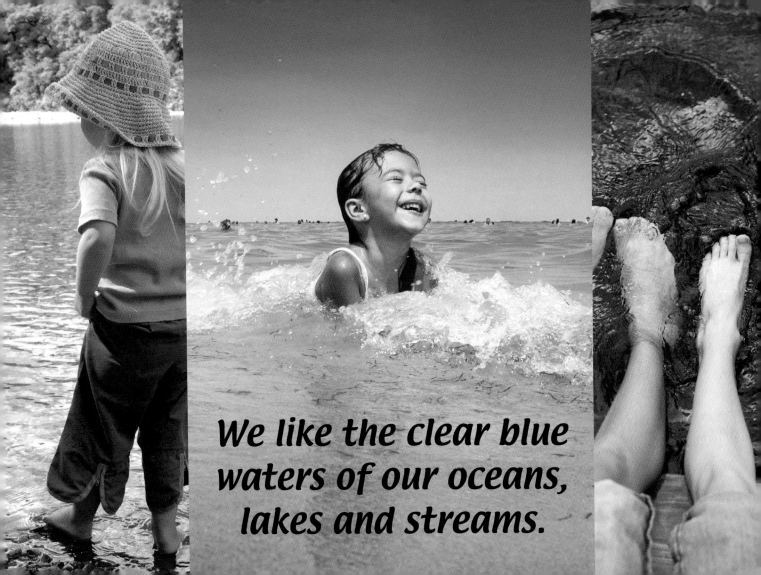

We like the clear blue waters of our oceans, lakes and streams.

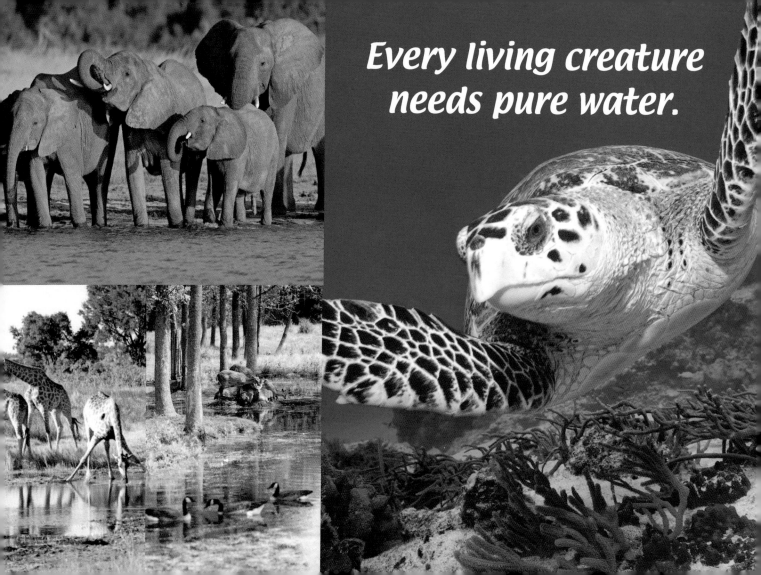

Every living creature needs pure water.

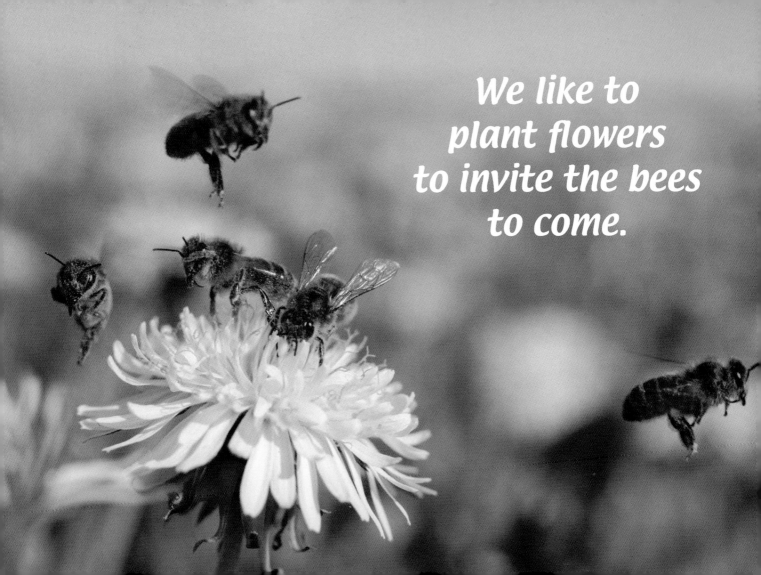

We like to
plant flowers
to invite the bees
to come.

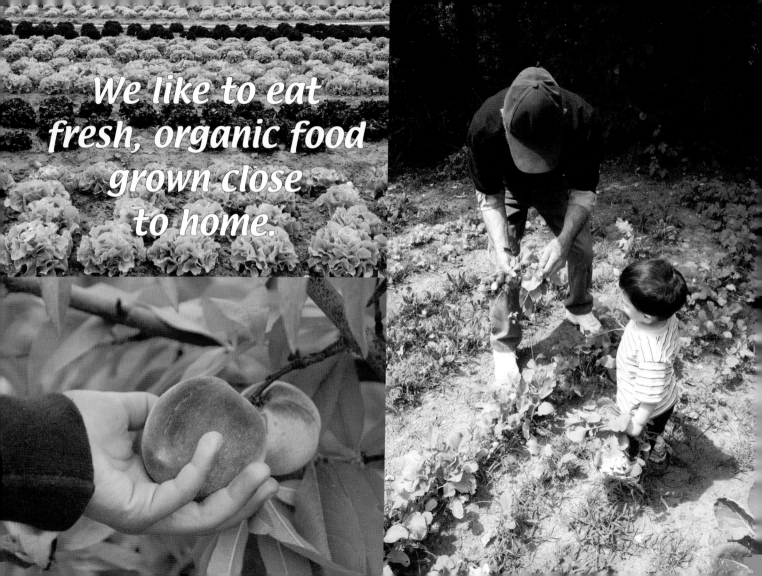

We like to eat fresh, organic food grown close to home.

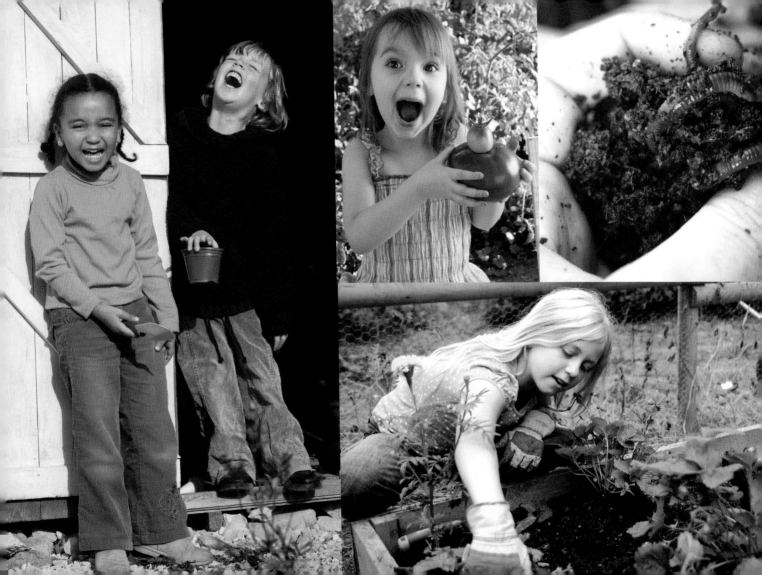

We like to garden.
We use scraps of
vegetables and
plants to make
compost that
enriches the soil.

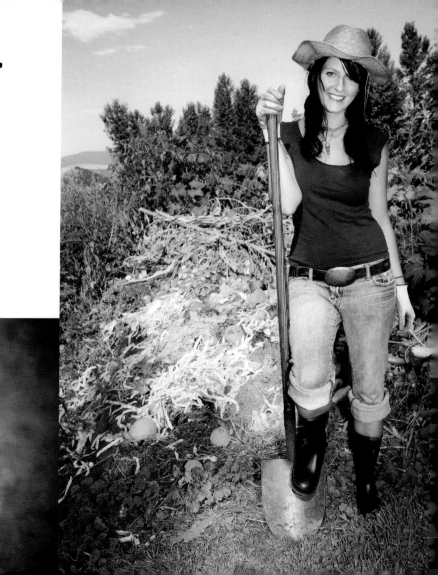

We like to recycle and reuse. We return glass, paper, cans and plastic.

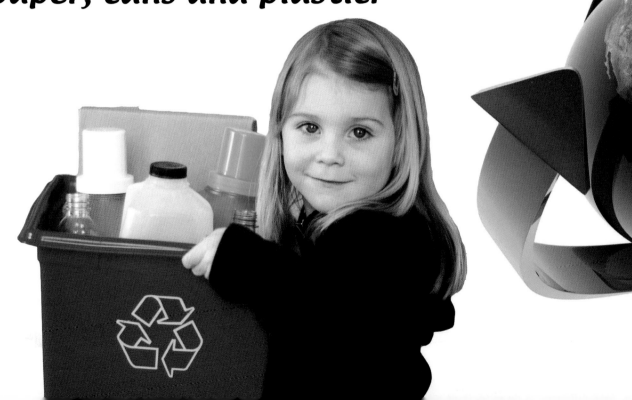

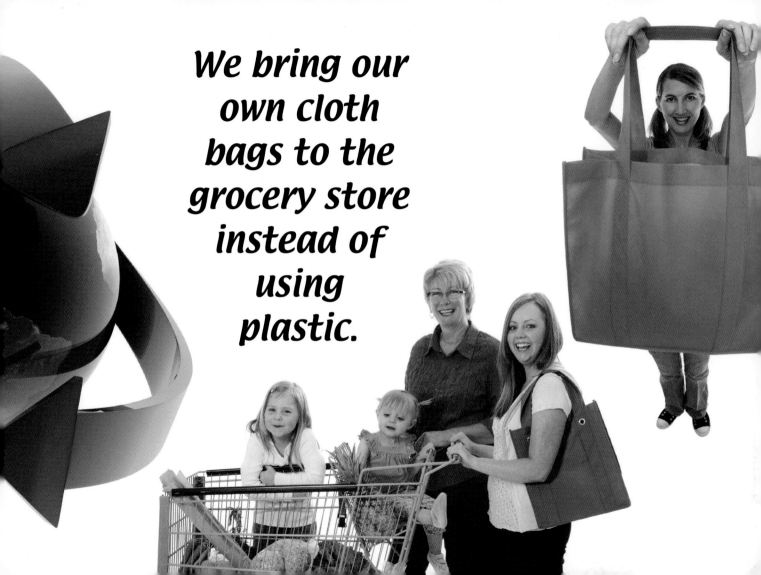

We bring our own cloth bags to the grocery store instead of using plastic.

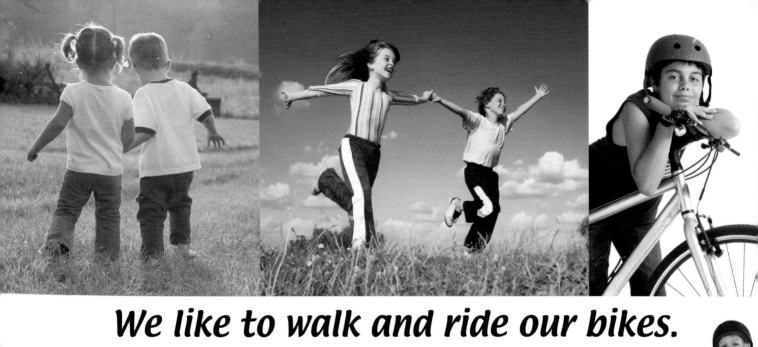

We like to walk and ride our bikes.

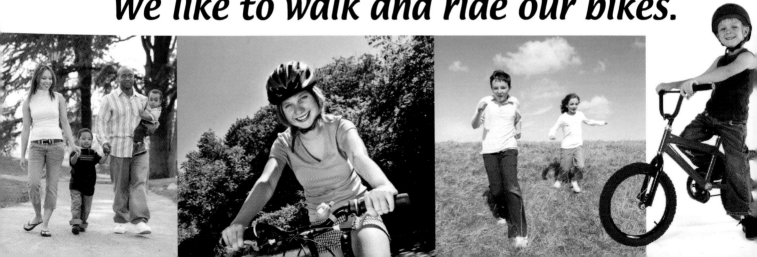

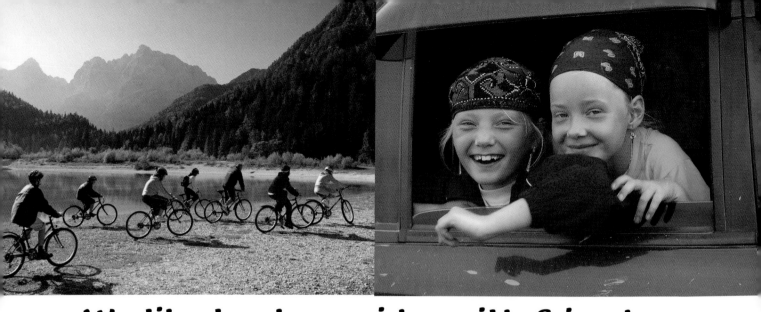

We like to share rides with friends.

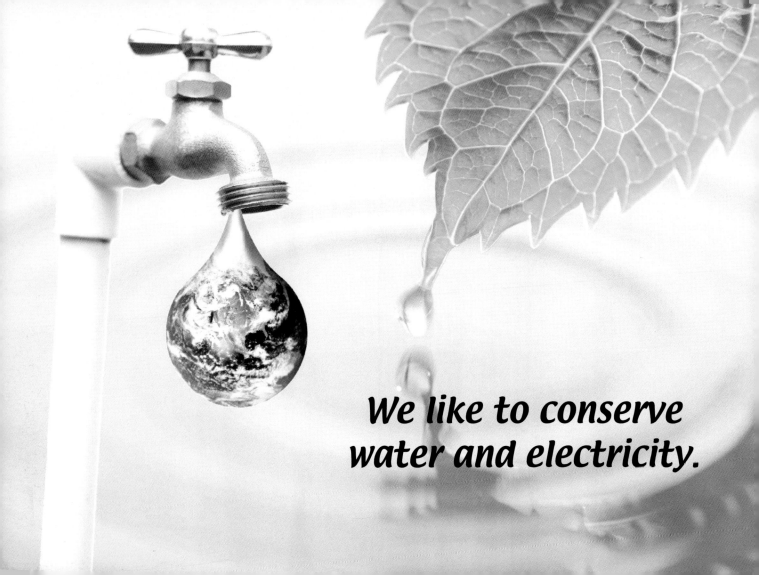

We like to conserve water and electricity.

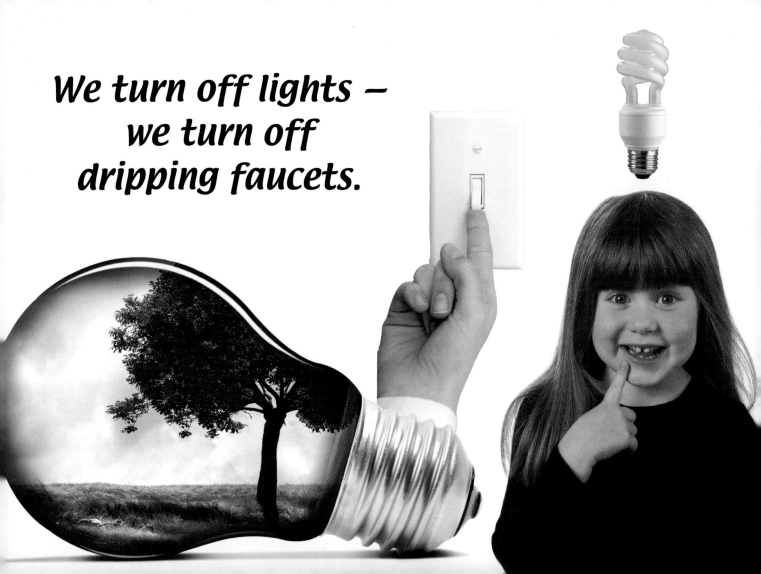

We turn off lights –
we turn off
dripping faucets.

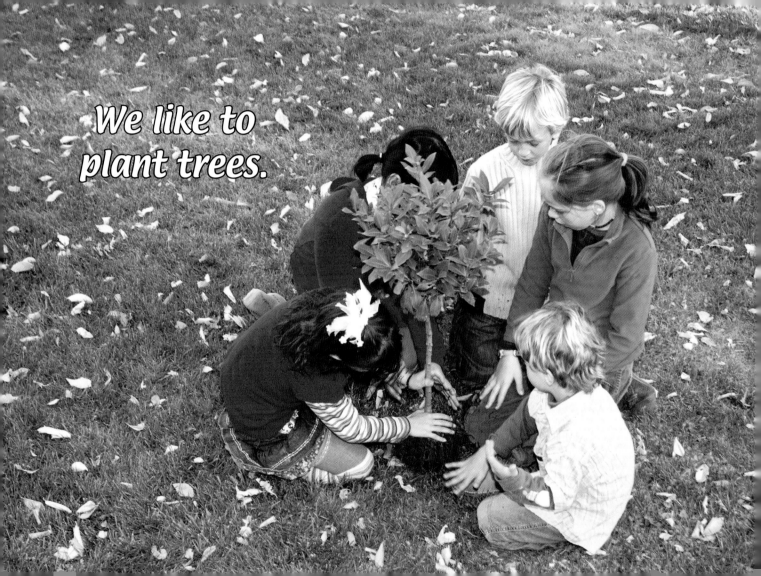

We like to
plant trees.

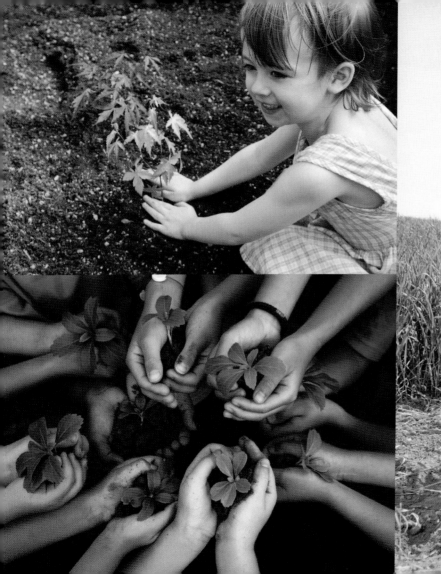

Trees make
the oxygen we
breathe.

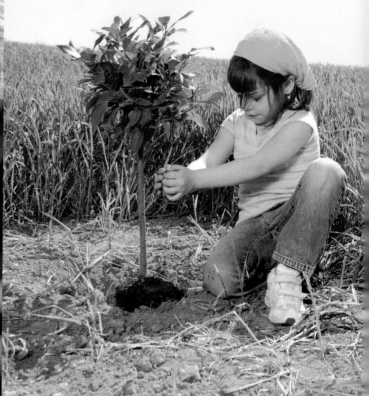

We like to take care of the Earth.

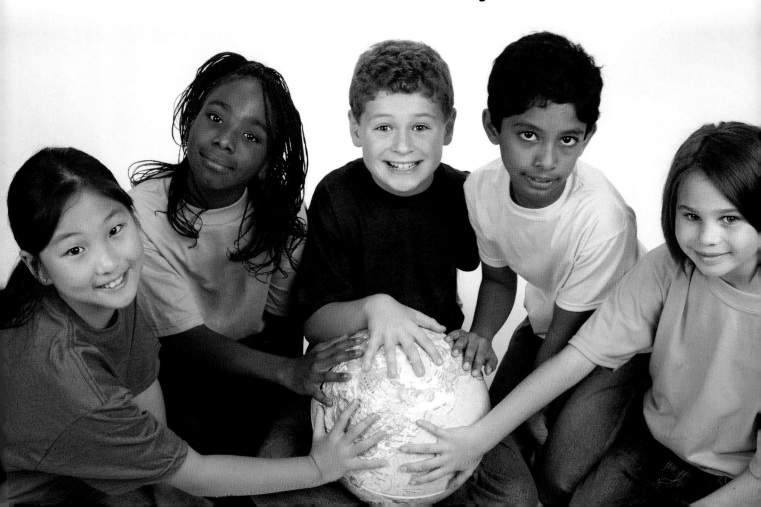

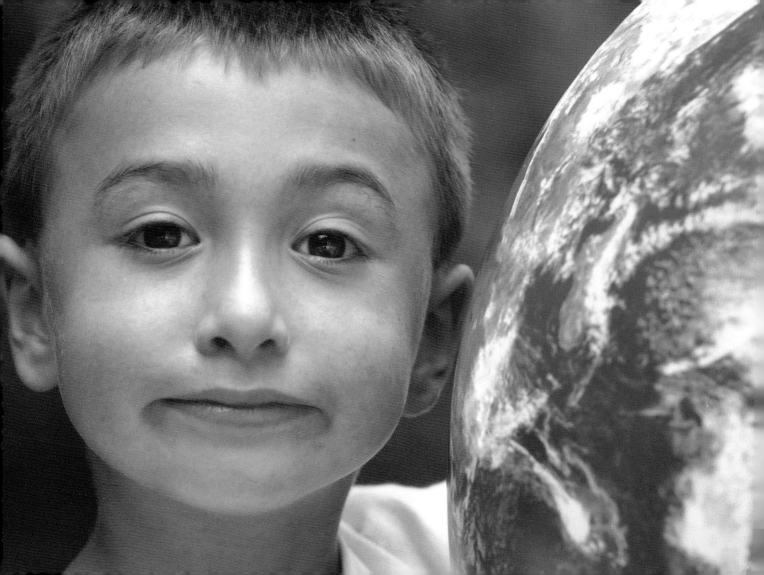

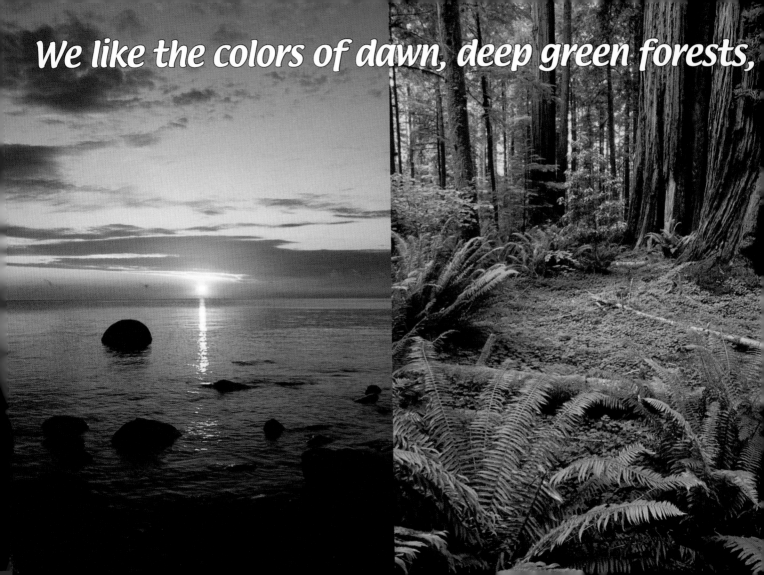

We like the colors of dawn, deep green forests,

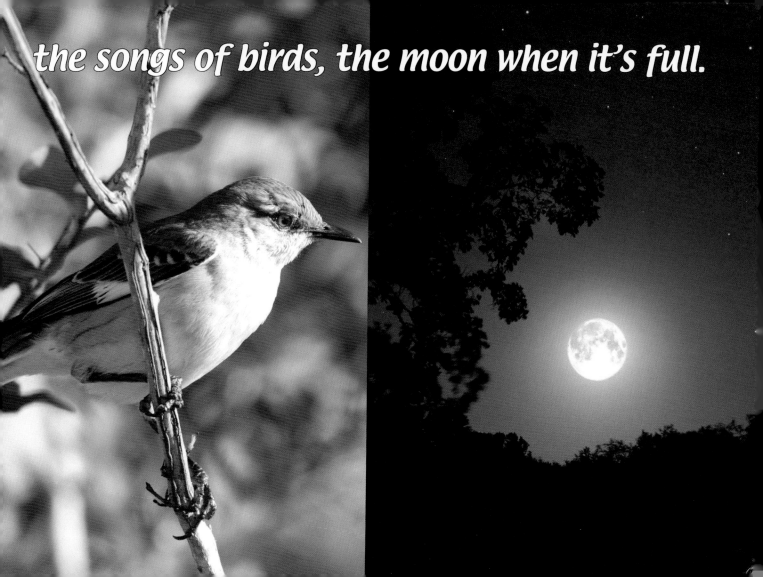

the songs of birds, the moon when it's full.

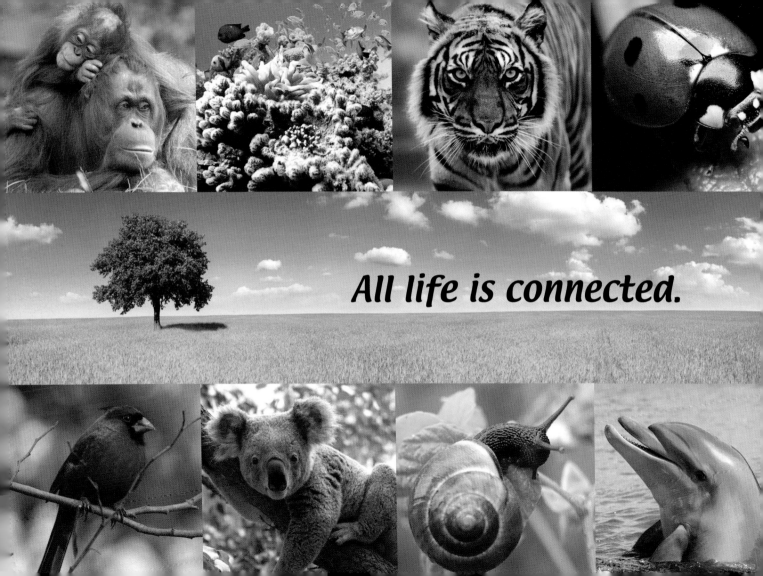

All life is connected.

We like to keep the Earth green.
We love our Earth.

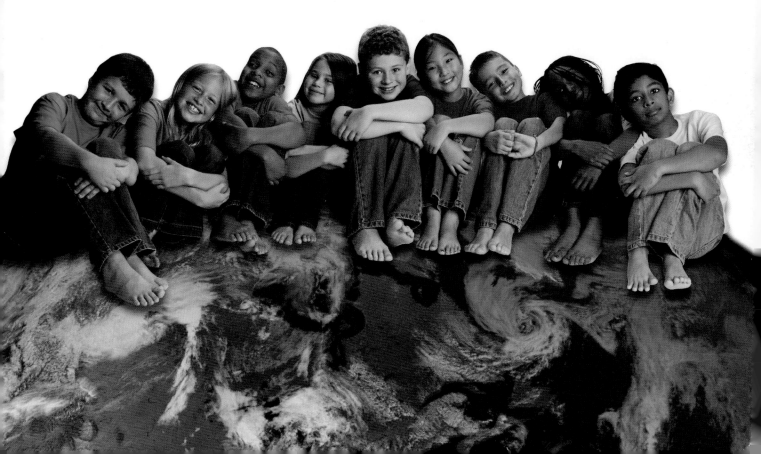

OTHER FAMILY-HEALTH / WORLD-HEALTH TITLES FROM HOHM PRESS:

We Like To Nurse Too
by M. Young
Design by Zachary Parker
Captivating and colorful illustrations present mother sea-animals nursing their young. The warmly encouraging and simple text supports the relationship of nursing.
ISBN: 978-1-890772-98-7, paper, 32 pages, $9.95
Bi-lingual Version: *También a Nosotros Nos Gusta Amamantar*
ISBN: 978-1-890772-99-4

We Like To Help Cook
by Marcus Allsop
Illustrations by Diane Iverson
Based on the USDA Food Pyramid guidelines, young children help adults to prepare healthy, delicious foods. (Ages: 2-6)
ISBN: 978-1-890772-70-3, paper, 32 pages, $9.95
Spanish Language Version: *Nos Gusta Ayudar a Cocinar*
ISBN: 978-1-890772-75-8

We Like To Play Music
by Kate Parker
Design by Zachary Parker
An easy-to-read picture book with photos of children playing music, moving to a beat and enjoying music alone and with parents and peers.
ISBN: 978-1-890772-85-7, paper, 32 pages, $9.95
Bi-lingual Version: *Nos Gusta Tocar Música*
ISBN: 978-1-890772-90-1

We Like To Eat Well
by Elyse April
Illustrations by Lewis Agrell
This book celebrates healthy food, and encourages young children and their caregivers to eat well, and with greater awareness. (Ages: Infants-6)
ISBN: 978-1-890772-69-7, paper, 32 pages, $9.95
Spanish Language Version: *Nos Gusta Comer Bien*
ISBN: 978-1-890772-78-9

TO ORDER: 800-381-2700, or visit our website, www.hohmpress.com *Special discounts for bulk orders.